DURHAM CITY

CITY

HISTORY TOUR

First published 2009
This edition published 2014

Amberley Publishing
The Hill, Stroud, Gloucestershire, GL5
4EP
www.amberley-books.com

Copyright © Michael Richardson, 2014

The right of Michael Richardson to be
identified as the Author of this work
has been asserted in accordance with
the Copyrights, Designs and Patents Act
1988.

ISBN 978 1 4456 4354 0 (print)
ISBN 978 1 4456 4390 8 (ebook)

British Library Cataloguing in
Publication Data.
A catalogue record for this book is
available from the British Library.

Typesetting by Amberley Publishing.
Printed in Great Britain.

INTRODUCTION

This collection of photographs is published here for the first time. The images are taken from the Gilesgate Archive, which has become a significant collection relating to the city and its people, covering the period from the 1850s to the 1960s.

The pictures chosen show how Durham has altered to cope with the demands of an ever-growing city. Many of the changes have been beneficial; however, some have not been so welcome. A few of my favourites are: the view from Paradise Lane, looking across Claypath towards Palace Lane; the tree-lined street of Gilesgate, showing the 'duck pond' area; the Western Hotel at the bottom of Albert Street; and the unveiling of the First World War memorial belonging to St. Godric's RC church, commemorating men of the parish who made the ultimate sacrifice.

Several of the old images are accompanied by a recent (April–May 2009) colour photograph to show the reader what change has occured. A special contribution to this volume came from Mr Frank Wilson, a local amateur photographer, who captured the city in the 1950s and into the 1960s. His pictures are meticulously dated; most even have the time they were taken written on the reverse. His gift to the archive has filled an important gap.

With the increasing popularity of the digital camera, more

photographs are being taken now than ever before in the history of photography. We should, therefore, have a good record of the city at the beginning of the twenty-first century for future generations. This selection will stir up memories of old familiar places: lost vennels, passageways and business premises, once trodden and visited by you, the reader, or your ancestors.

Michael Richardson

British Legion's Women's Section, Market Place, 3 December 1946.

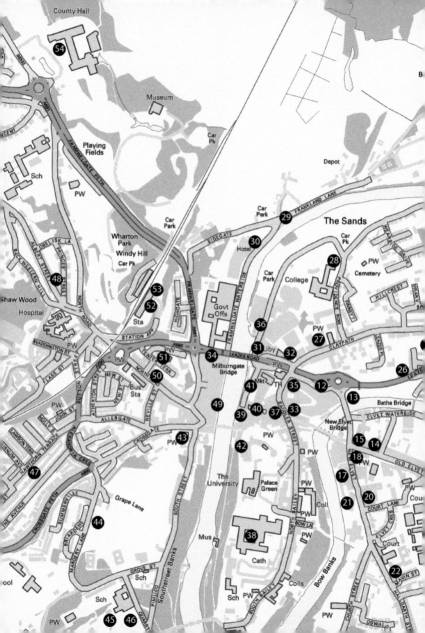

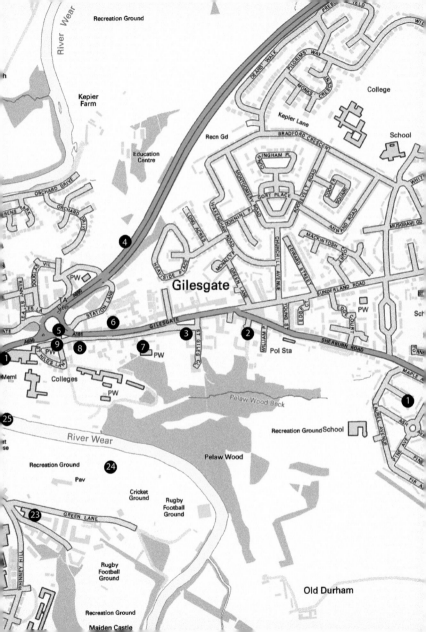

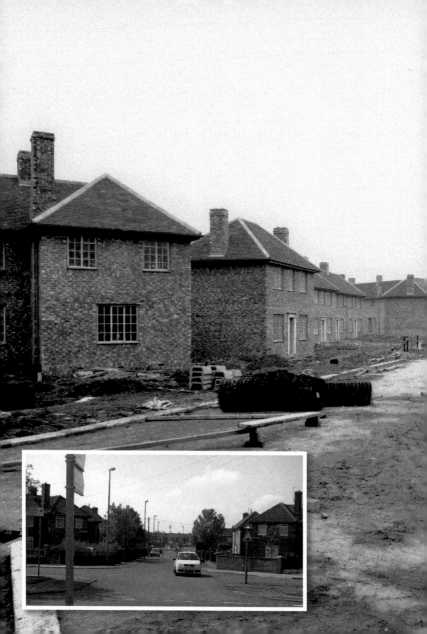

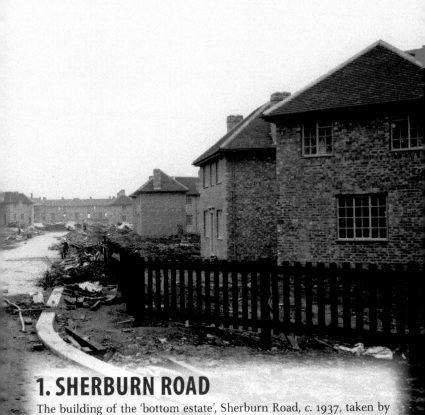

1. SHERBURN ROAD

The building of the 'bottom estate', Sherburn Road, *c.* 1937, taken by Daisy Edis. This new development was then the pride of Durham City Council; in February 1939, King George VI and Queen Elizabeth paid a special visit to look at these new homes. They are now renamed The Woodlands and are managed by Home Housing Association Ltd.

2. THE STABLE YARD

The 'Stable Yard' (later known as Newton's rag-yard), Sherburn Road Ends, 1920s, showing a horse and cart belonging to J. Fenwick, fruit and potato merchant. The large building in the background is the former Militia Barracks (Vane Tempest Hall). The yard is now occupied by a hostel named Webster House, after Donald Webster, a past vice principal of Bede College.

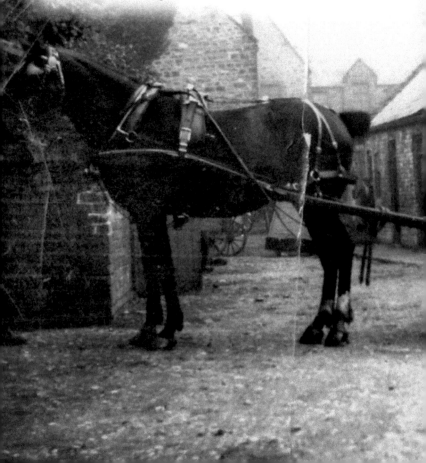

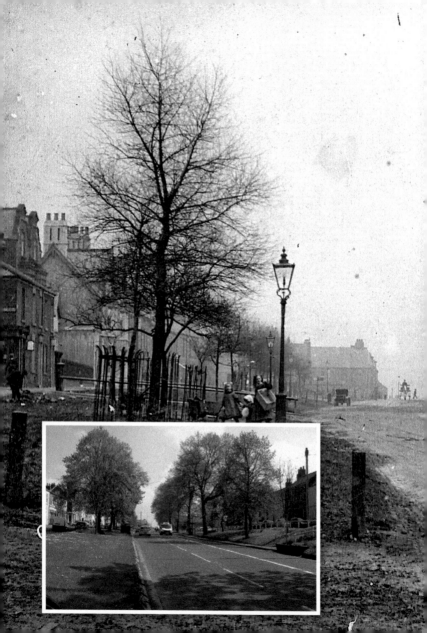

3. GILESGATE BANK

A view of the top of Gilesgate Bank showing, on the right, the area commonly called the 'duck pond', in the 1900s. On the extreme right edge is the horse trough, which still survives. This trough was originally in Old Elvet and was brought here around 1896 to replace an older one. A new circular one in Elvet had been presented to the city by Coroner Graham and his wife.

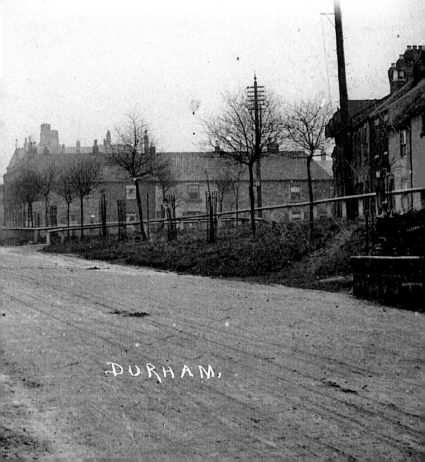

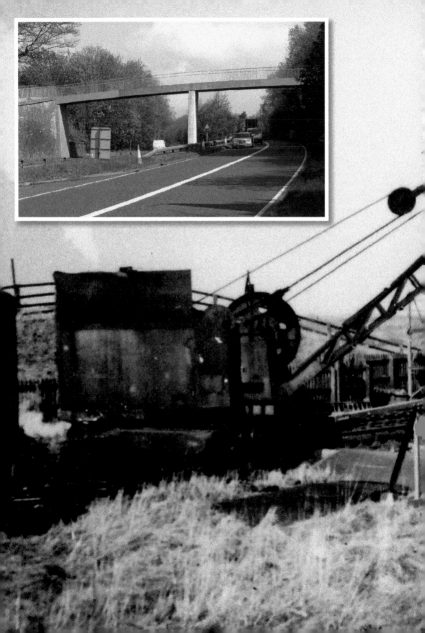

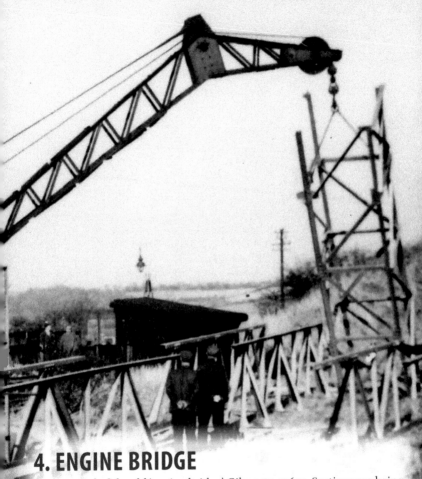

4. ENGINE BRIDGE

The removal of the old 'engine bridge', Gilesgate, 1960s. Sections are being placed on the south side of the line. This iron and wooden footbridge was situated near Heaviside Place, a little north-east of the ruined Magdalen chapel (1451). It crossed the railway line belonging to Gilesgate goods station. It was replaced by the present concrete footbridge (a little further towards the chapel) when the A690 road was constructed.

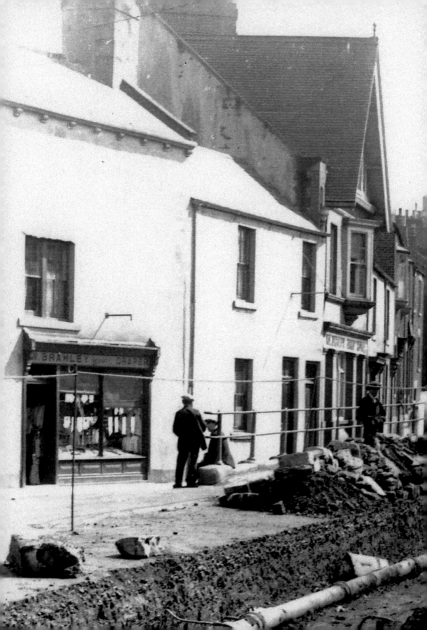

5. CAUSEY FOOT

Looking up Gilesgate Bank from the area then known as the 'causey foot', 1923, taken by John Edis. The railings on the left belonged to the 'dry bridge' which was removed during these major roadworks. The shop was Bramley's drapers. The gable-roofed building was the Volunteer Arms public house. Properties to the lower left and right were removed for the new road system in the 1960s.

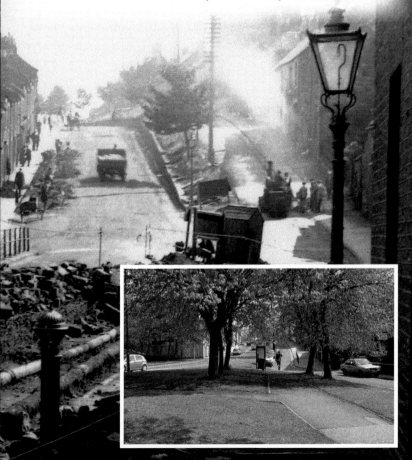

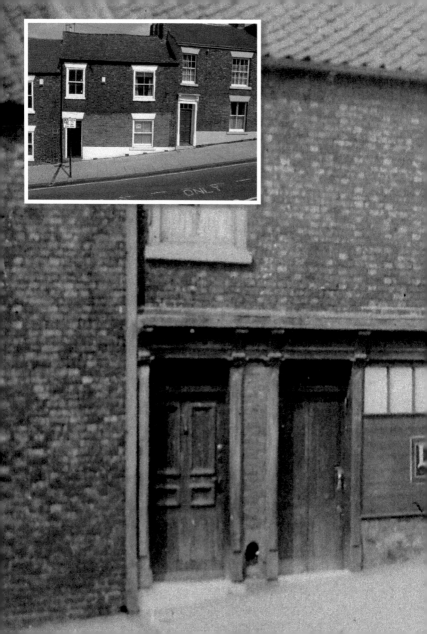

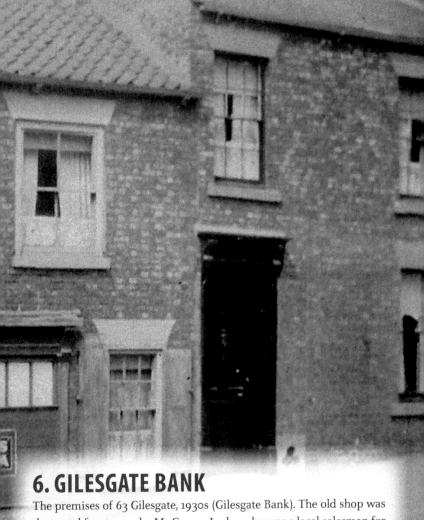

6. GILESGATE BANK

The premises of 63 Gilesgate, 1930s (Gilesgate Bank). The old shop was then used for storage by Mr George Larke, who was a local salesman for Lyon's tea (note the pantiled roofs). In more recent years the property was a newspaper shop and it has now been converted to a dwelling.

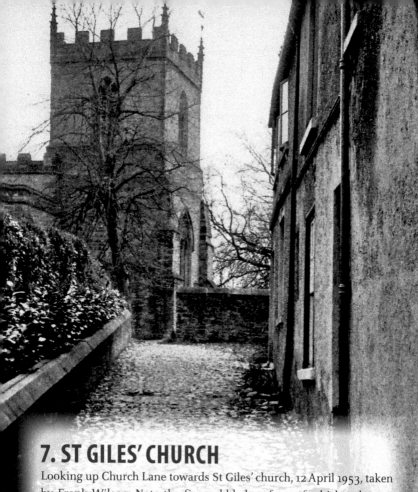

7. ST GILES' CHURCH

Looking up Church Lane towards St Giles' church, 12 April 1953, taken by Frank Wilson. Note the fine cobbled surface, of which only part remains. Some of the cobbles are now lost, having been removed and replaced by a tarmac path leading to one of the cottages. The wall at the top of the lane was part of the churchyard boundary; this was removed to make way for the new church hall, built in the early 1960s.

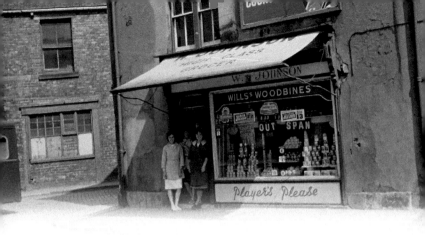

8. GILESGATE BANK

The shop of W. Johnson, high-class grocer, at the bottom of Gilesgate Bank, early 1960s. It had previously been that of Johnson and Cosgrove and prior to that it was a draper, W. Bramley. The van to the left is seen leaving Station Lane; this area is now an open space, near the present roundabout.

9. ST HILD'S LANE

St Hild's Lane, looking towards Bede College, 12 April 1953, taken by F. Wilson. The building on the right was St. Hild's Practising School. It stood adjacent to the infant school building (off the picture), which had been there since 1864 (both now used by the university). The Practising School was constructed by local builder, John Shepherd, and was opened in 1911. It closed in 1965, when a new school was opened in Mill Lane, Gilesgate Moor.

10. RAVENSWORTH TERRACE

Ravensworth Terrace, leading down off Gilesgate, 12 April 1953, taken by F. Wilson. The property at the bottom, Pelaw Leazes, along with two houses from the terrace, were removed to make way for the new Leazes Road in the 1960s. These grand Victorian town houses (built in 1887) have basement kitchens and attic rooms for servants; several are now student occupied.

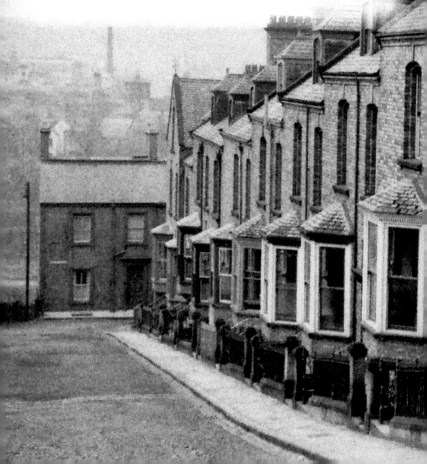

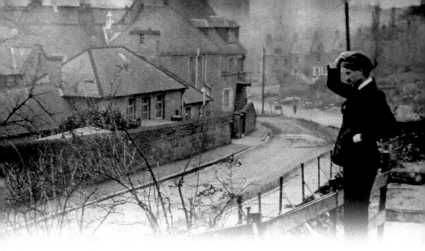

11. LEAZES ROAD

The new Leazes Road under construction, early 1960s. This photograph was taken after complications arose regarding the ownership of a small strip of land which was in the centre of the road development. An official pauses for reflection and scratches his head in frustration. On the left are buildings belonging to Bede College, and in the distance is Ravensworth Terrace.

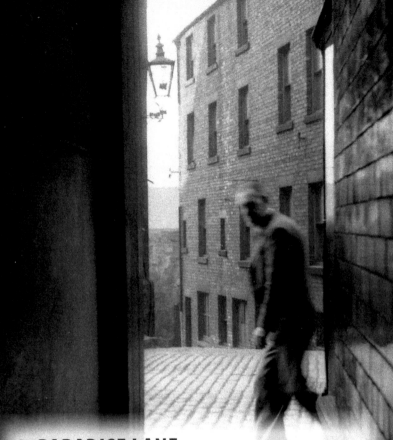

12. PARADISE LANE

Looking from Paradise Lane across Claypath towards Walkergate (Palace Lane/Back Lane) 22 March 1953, taken by F. Wilson. Many of these old vennels and passageways dated back to medieval times. These two were lost in the early 1960s when the new road system was built. The slip road to Leazes Bowl roundabout and the Prince Bishops shopping centre now occupy part of the lane which eventually came out behind Brown's boathouse.

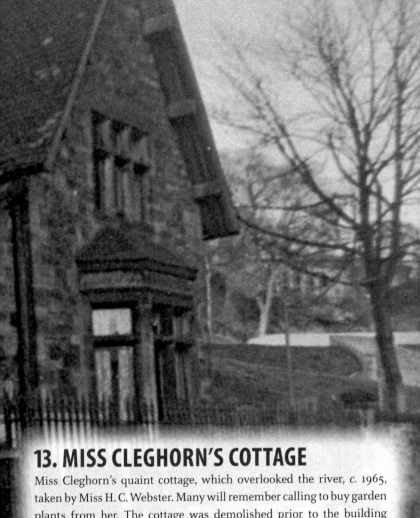

13. MISS CLEGHORN'S COTTAGE

Miss Cleghorn's quaint cottage, which overlooked the river, *c.* 1965, taken by Miss H. C. Webster. Many will remember calling to buy garden plants from her. The cottage was demolished prior to the building of the New Elvet road bridge, which now passes almost directly over the site. On the skyline (left) is part of the now demolished Blue Coat School in Claypath.

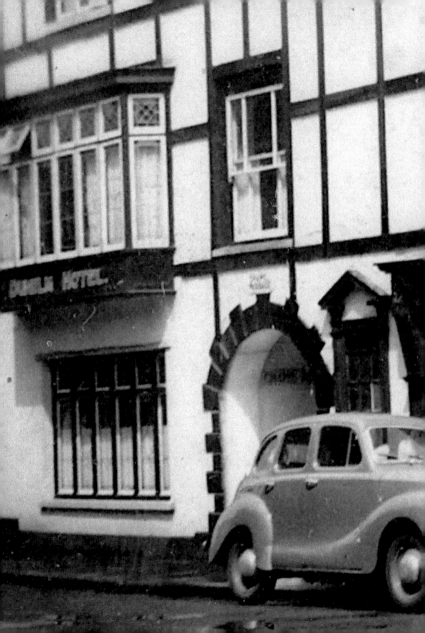

14. DUNELM HOTEL

The Dunelm Hotel, Old Elvet, 1950s. The arched entrance on the left was called Chapel Passage because it once led to the old Methodist chapel (opened 1808). The Dunelm is now part of the Royal County Hotel, and the archway has become a window for the dining room.

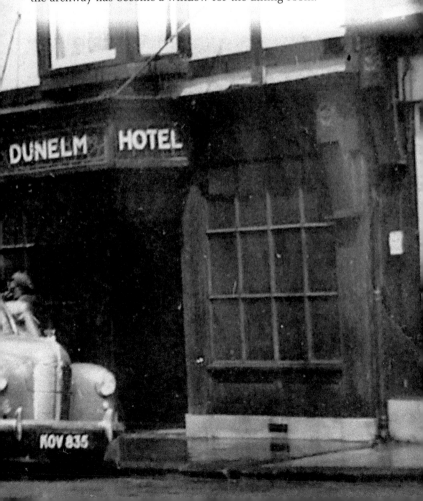

15. ROYAL COUNTY HOTEL

An advertisement postcard from the Royal County Hotel, Old Elvet, *c*. 1909. The card states that it then had its own riverside landing stage. The base of the central lamp-stand was also a horse-trough. The doorway with the lamp above, on the extreme left, belonged to the Waterloo Hotel. The latter was removed in the early 1970s to make way for the New Elvet road bridge.

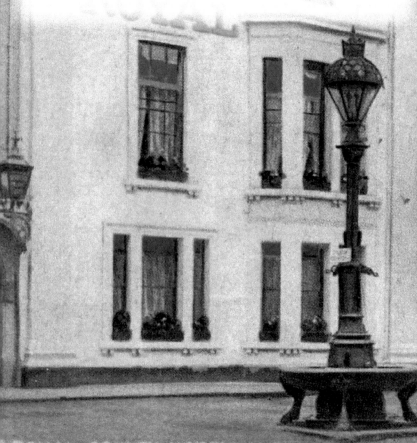

ROYAL COUNTY HOTEL DURHAM

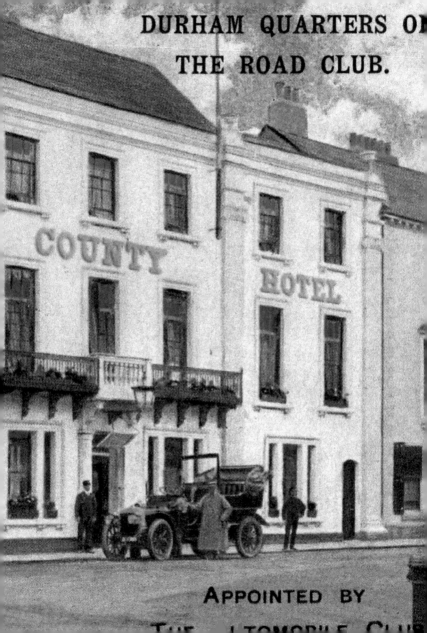

16. DURHAM COUNTY COURT

The frontage of Durham County Court (now the Crown Court), Old Elvet, 1880s. A group of city policemen are posing for the camera at 5.43 p.m. The building was started by Francis Sandys in 1809; poor workmanship led to him being replaced by George Moneypenny in 1812. The latter's work was no better. Finally, in 1814, the county architect, Ignatius Bonomi, was appointed to complete the task.

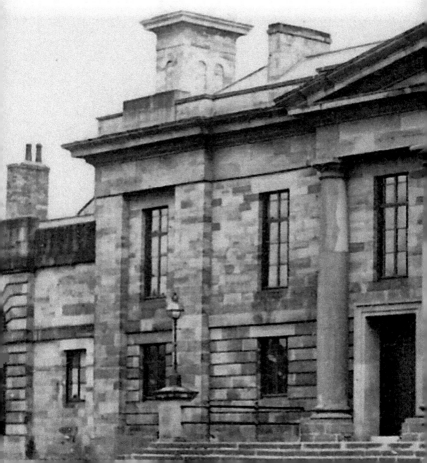

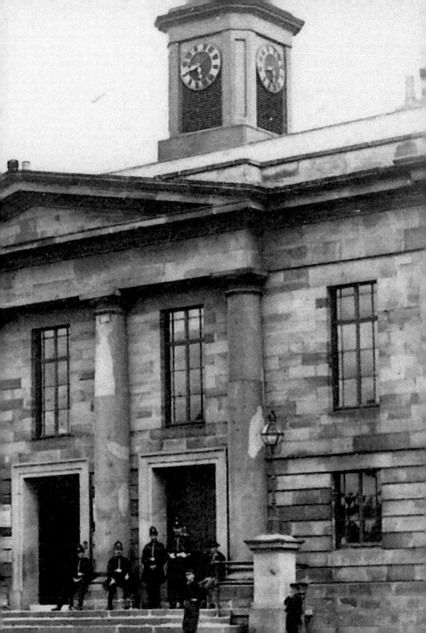

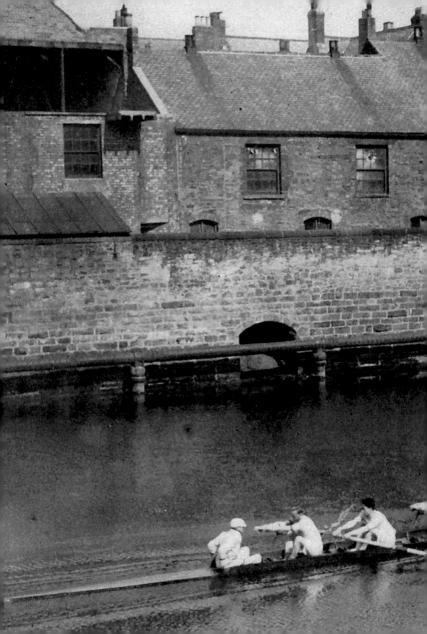

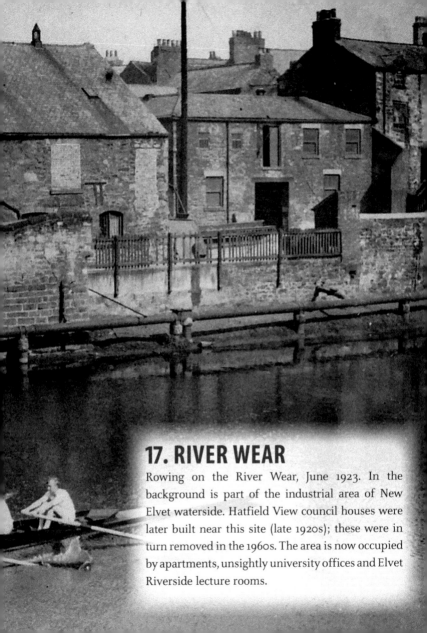

17. RIVER WEAR

Rowing on the River Wear, June 1923. In the background is part of the industrial area of New Elvet waterside. Hatfield View council houses were later built near this site (late 1920s); these were in turn removed in the 1960s. The area is now occupied by apartments, unsightly university offices and Elvet Riverside lecture rooms.

18. NEW AND OLD ELVET

The junction of New and Old Elvet, 15 March 1953, taken by F. Wilson. On the extreme left is the copper dome of Shire Hall (built in 1896–98 and extended in 1905). The central spire belongs to Elvet Methodist church (opened 4 November 1903). The corner shop was then Rutherford's newsagents.

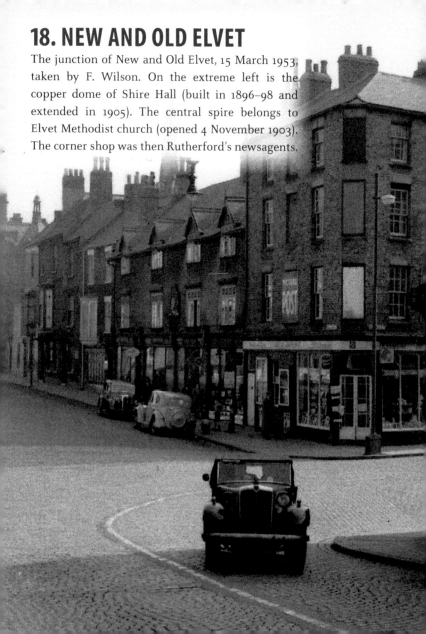

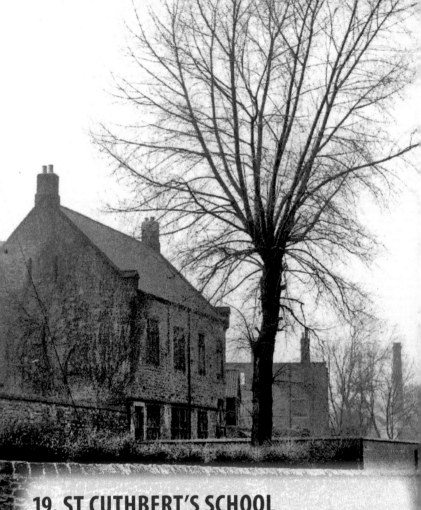

19. ST CUTHBERT'S SCHOOL

St Cuthbert's Roman Catholic School (1847–1961), Old Elvet, 22 March 1953, viewed from The Racecourse, and taken by F. Wilson. The proximity of the river occasionally caused flooding in the lane behind the stone wall. The old school, now converted into a house, looks more like a Spanish holiday villa, complete with concrete lion heads.

20. NEW ELVET

Fowler & Armstrong's garage, New Elvet, 15 March 1953, taken by F. Wilson. The garage had originally been situated further down the street, opposite the Three Tuns Hotel. Orchard House, apartments for the over fifties were later built on this site, carefully designed to fit in with the old street.

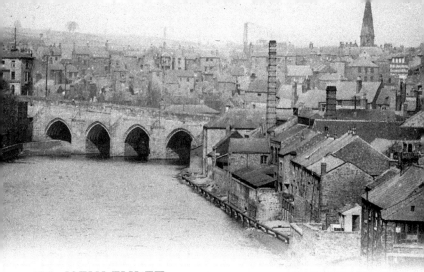

21. NEW EVLET

A rooftop view of New Elvet waterside, *c.* 1911. This was then a well-populated business area. The site is now occupied by university offices, Elvet Riverside lecture rooms and part of Dunelm House. Prominent on the skyline is the spire of the Congregational church, Claypath.

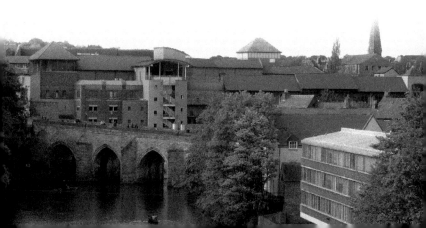

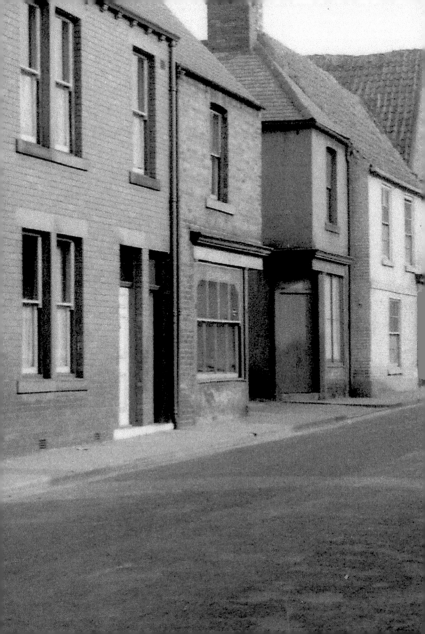

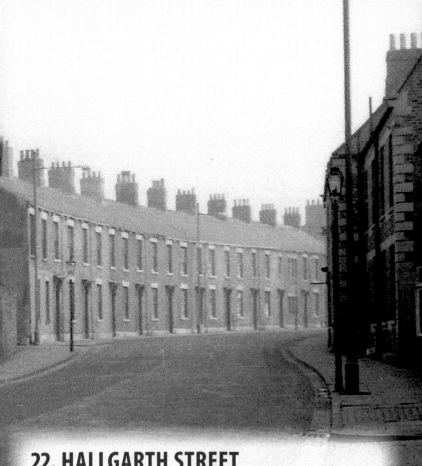

22. HALLGARTH STREET

Hallgarth Street, from near the Victoria public house, 22 March 1953, taken by F. Wilson. The central sweeping terrace of early Victorian town houses is now mainly let to students. The street took its name from the hall and garth belonging to the nearby priory estate farm. The shop, on the left, is now a restaurant called Elcoto, and the second shop is now converted into a dwelling for students.

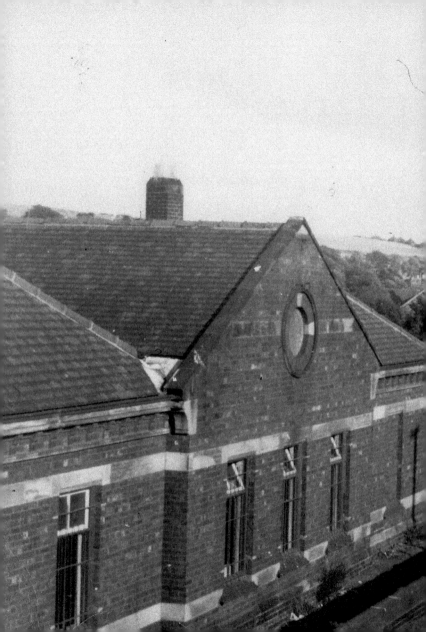

23. ELVET RAILWAY STATION

Elvet railway station from the foot of Whinney Hill, 1950s, taken by Alan Maitland. The public footpath, alongside, which then led to Maiden Castle Hill, is now closed. The site of the station building is now occupied by Durham Justice Centre (previously the Magistrates' Court). On the central skyline are the rooftops of the Earl Haig Houses, on the Sherburn Road estate.

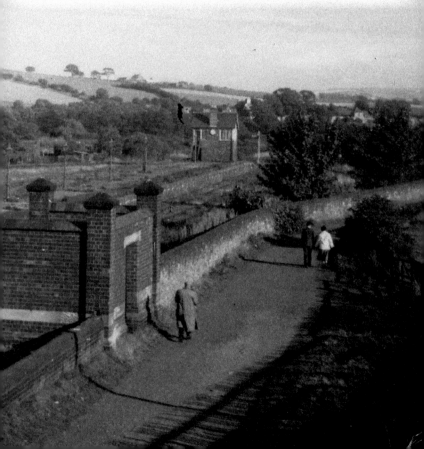

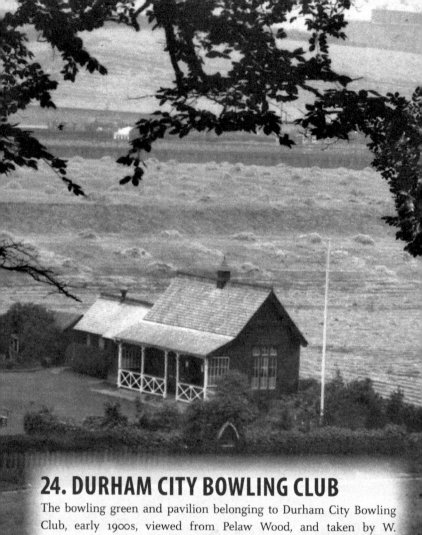

24. DURHAM CITY BOWLING CLUB

The bowling green and pavilion belonging to Durham City Bowling Club, early 1900s, viewed from Pelaw Wood, and taken by W. Wilkinson. The club was founded around 1888/89. The hay stooks, on the racecourse, are an indication that the land was then being used to grow animal feed.

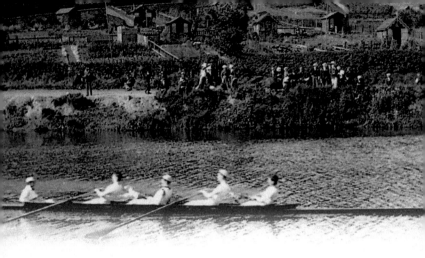

25. DURHAM REGATTA

Durham Regatta viewed from the racecourse in 1900. Known as the 'Henley of the North', the first race was held in 1834. It is the second oldest rowing regatta in England.

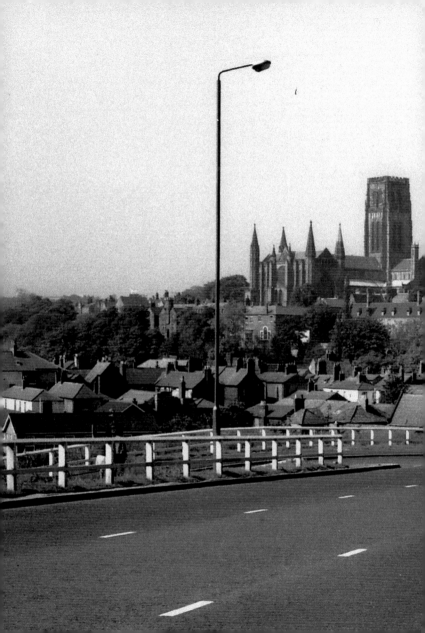

26. LEAZES ROAD

The newly opened Leazes Road, looking across Elvet towards the cathedral and castle, late 1960s. This fine view of the city is now partly lost, due to the planting of trees on the bankside. Note the long, white-painted fence, which is no longer in place.

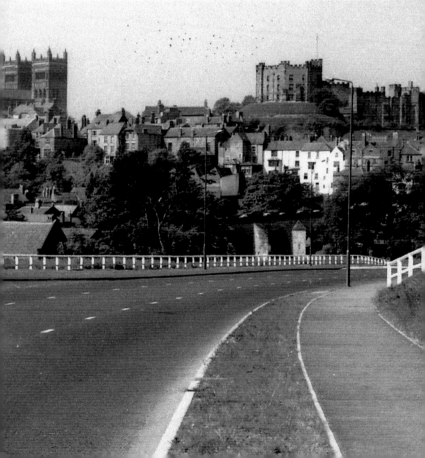

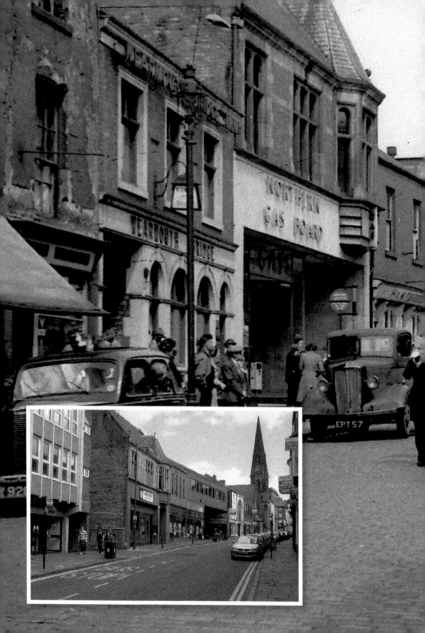

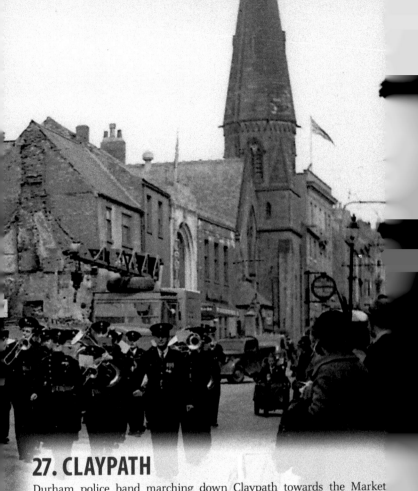

27. CLAYPATH

Durham police band marching down Claypath towards the Market Place, 12 May 1951, taken by F. Wilson. On the left is the Wearmouth Bridge public house, and on the pub's left, behind the car, is Norman Richardson's first travel agency. The area is now occupied by an access road and offices.

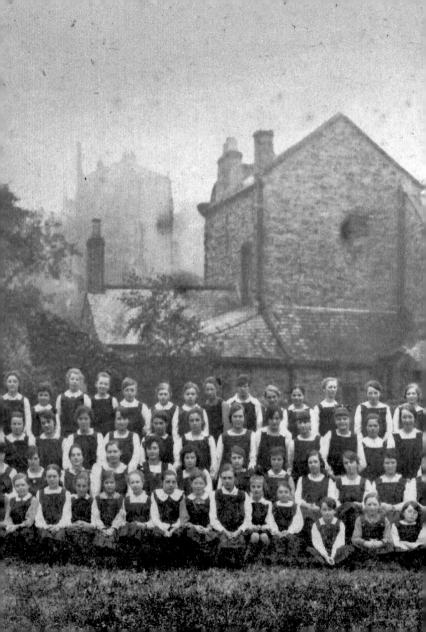

28. DURHAM GIRLS' COUNTY SCHOOL

Pupils from the Durham Girls' County School, Providence Row, 1921. The building behind the group was called Ebenezer Cottage and was unusual in style with various extensions added. It was originally reached by a path from Chamber's Yard, Claypath. Later, the cottage had its own drive from Providence Row.

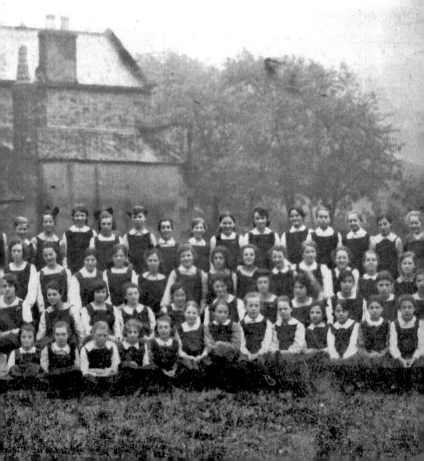

29. SIDEGATE

The ferry steps, Sidegate, 12 April 1953, taken by F. Wilson. The quaint cottages in the foreground were called Lishman's Buildings and behind them was the street of Sidegate. Those on the extreme right were named Lovegreen Street. This area is now redeveloped and is partly occupied by a car park.

30. SIDEGATE

The City of Durham gasworks, Sidegate, viewed from near Freeman's Place, 12 April 1953, and taken by F. Wilson. Behind the wooden fence on the opposite side of the river was Holiday Park dog track. Most of this site is now occupied by a new hotel (unreachable from the front when the river is in flood). On the skyline, to the left, is seen St Godric's church.

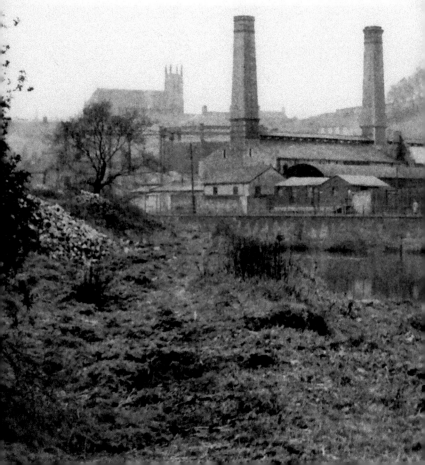

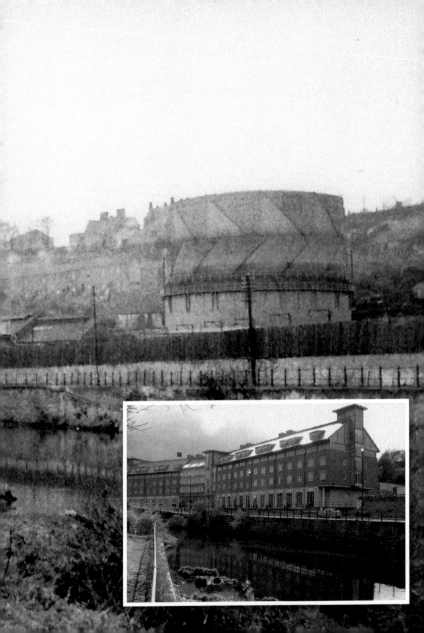

31. MILLBURNGATE BRIDGE

Looking towards the bottom end of Walkergate in the direction of the river, 12 April 1953, taken by F. Wilson. The photograph shows the premises belonging to E. Brown & Son, engineers, smiths and welders and further down is W. Stones, the window cleaner. The area is now the site of Millburngate Bridge, and access road to Freeman's Place and Fowler's Yard. Durham railway station can be seen on the skyline.

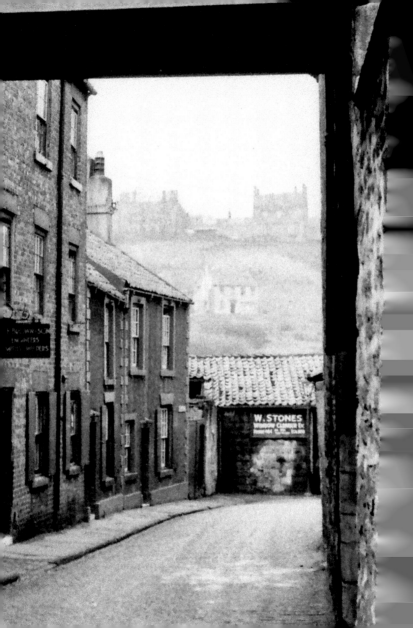

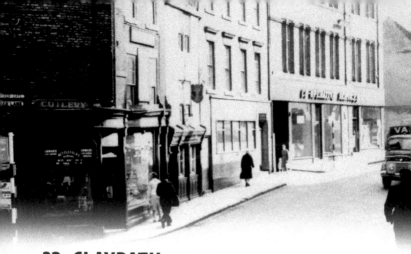

32. CLAYPATH

The beginning of Claypath, early 1960s. The properties were, left to right: St Nicholas' church hall corner, Palace Lane (Walkergate/Back Lane), Fleming and Neil, iron mongers, the Wheatsheaf public house, the Co-operative Bank, and the Co-operative Store (note the Vaux brewery wagon). The area is now occupied by the open space between the church hall, Claypath underpass and Millennium Place.

33. MARKET PLACE

Durham City Dairy Company (with tea-rooms upstairs), Market Place, 1920s. Its fine decorative shop frontage still survives, although partially hidden by plywood boarding; the ground floor is now occupied by an optician. On the right was Hepworth's the tailors. The property on the left was then empty (the date above that door was 1877). It is now a branch of the Nationwide Building Society.

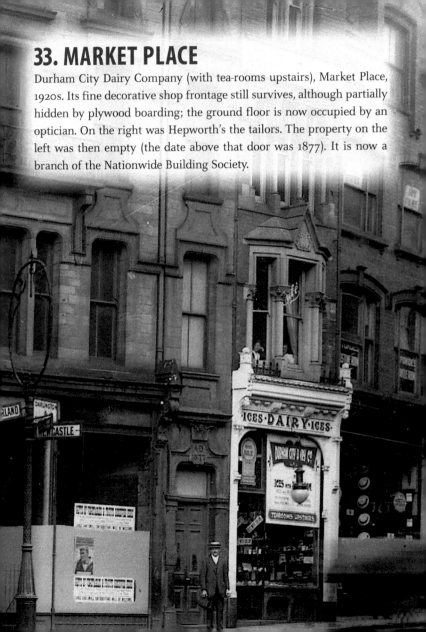

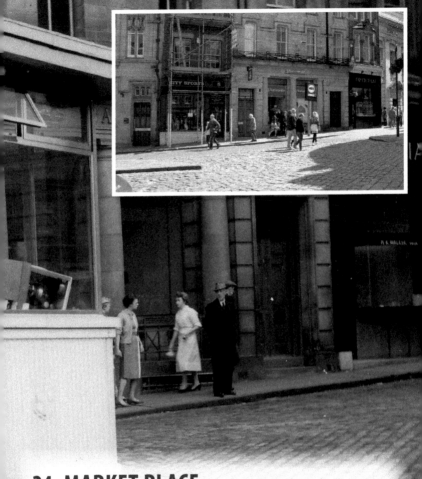

34. MARKET PLACE

The second and last police box, Market Place, October 1959. This remained until 1975, when the two old bridges, Elvet and Framwellgate, were pedestrianised. The Millburngate Bridge (officially opened 1967) and the New Elvet Bridge (officially opened 1976) now take all the traffic. Note, on the left, the former *Evening Chronicle* office.

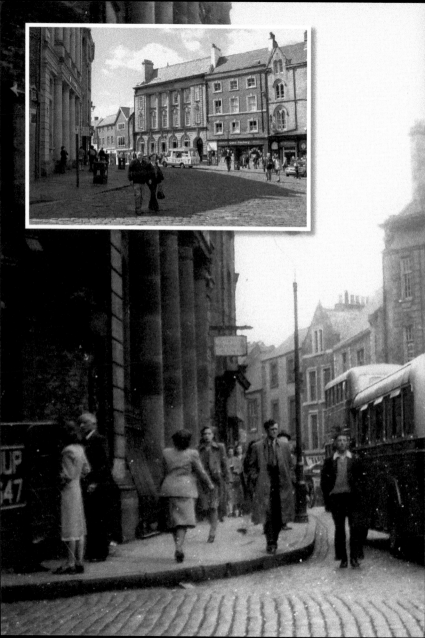

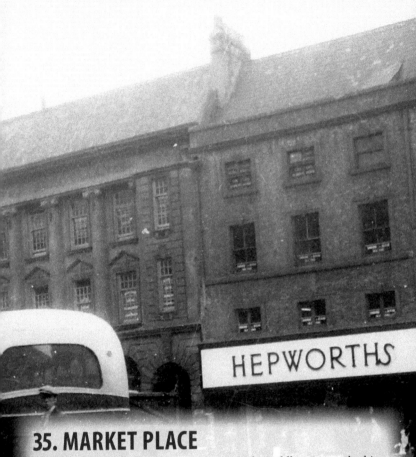

HEPWORTHS

35. MARKET PLACE

The Market Place from the junction with Saddler Street, looking towards Silver Street, *c.* 1947. The photograph shows the inappropriate signage belonging to Hepworth's the tailors (the shop now sells greetings cards). The two buses are waiting at their stands, before going down Silver Street.

36. MARKET PLACE MILL

Market Place Mill (also known as Martin's Mill, after a former owner), Walkergate, 12 April 1953, taken by F. Wilson. Part of the original medieval Bishop's Mill still survives – see the small pantiled building to its left. The tall chimney on the other side of the river, far left, belonged to the gas works in Sidegate. The light-coloured building, behind on the left, is the old ice rink.

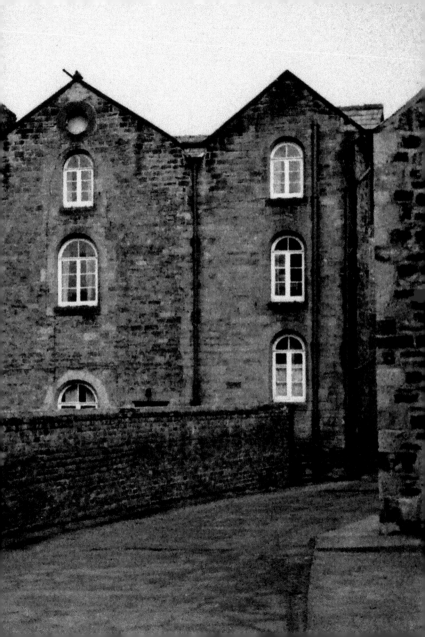

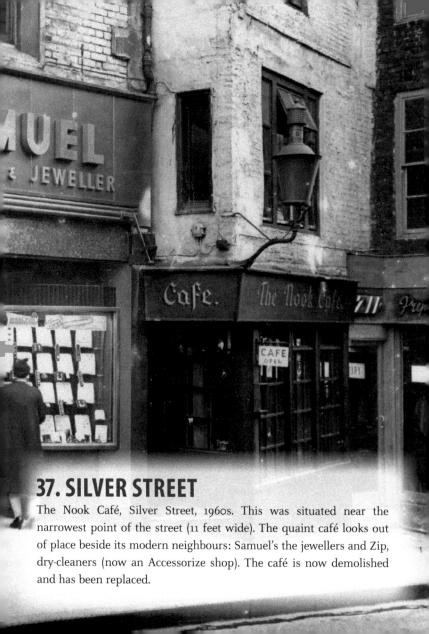

37. SILVER STREET

The Nook Café, Silver Street, 1960s. This was situated near the
narrowest point of the street (11 feet wide). The quaint café looks out
of place beside its modern neighbours: Samuel's the jewellers and Zip,
dry-cleaners (now an Accessorize shop). The café is now demolished
and has been replaced.

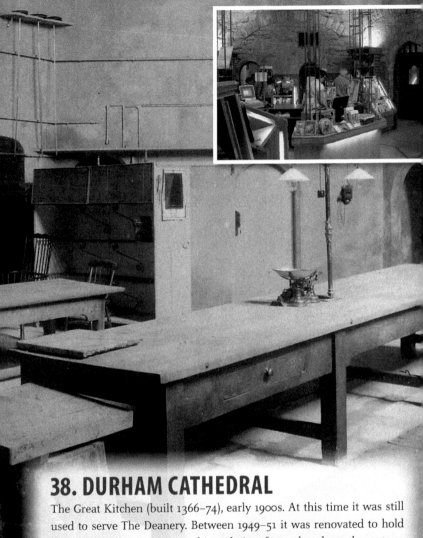

38. DURHAM CATHEDRAL

The Great Kitchen (built 1366–74), early 1900s. At this time it was still used to serve The Deanery. Between 1949–51 it was renovated to hold the cathedral's monastic archive, dating from the eleventh century. The plaster from the interior walls was removed 1969–71 to reveal the present stonework. The room, then part of the cathedral bookshop, was officially opened by the Prime Minister Tony Blair, in December 1997.

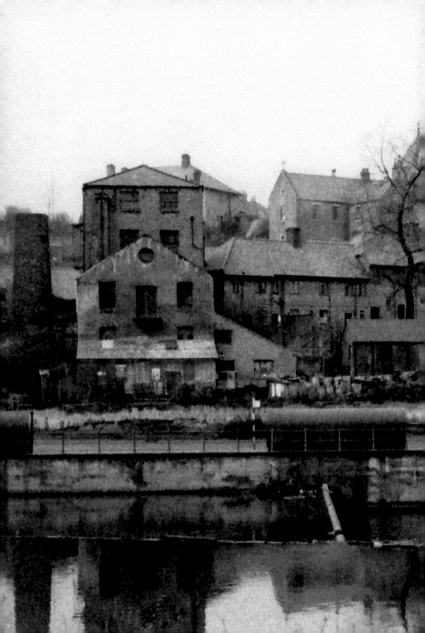

39. MILLBURNGATE

Millburngate, 12 April 1953, taken by F. Wilson. The terraced properties across the centre of the photograph were council houses, built before the Second World War. They were demolished when the new roads were constructed in the 1960s. The small white-painted building on the right was a pigeon loft, situated on an allotment garden.

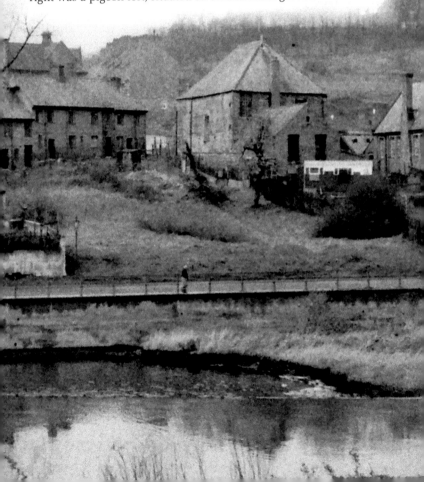

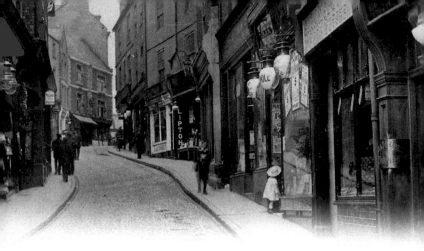

40. SILVER STREET

Looking up a quiet Silver Street towards the Market Place, 1920s. Named shops which are noticeable on the right are: Eastman the butcher; Lipton, grocer; Maypole, grocer; and Ramsbottom, pork butcher. Prior to the construction of Millburngate Bridge, this was one of the main arteries for all traffic passing through the city.

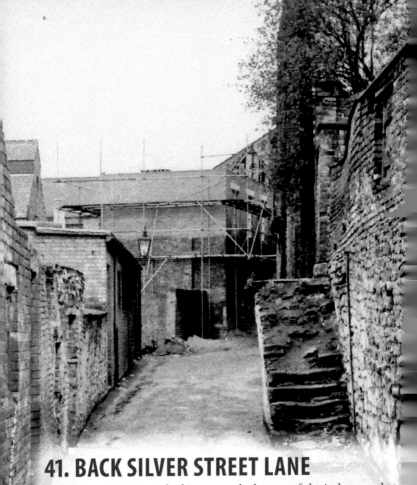

41. BACK SILVER STREET LANE

Back Silver Street Lane, looking towards the rear of the indoor market, 12 April 1953, taken by F. Wilson. The photograph shows the narrowness of this ancient lane. On the right are remains of derelict steps, which led to property behind the Market Place. The old warehouse in the background was then being enlarged by the adding of an extra floor (only for it to be demolished about ten years later).

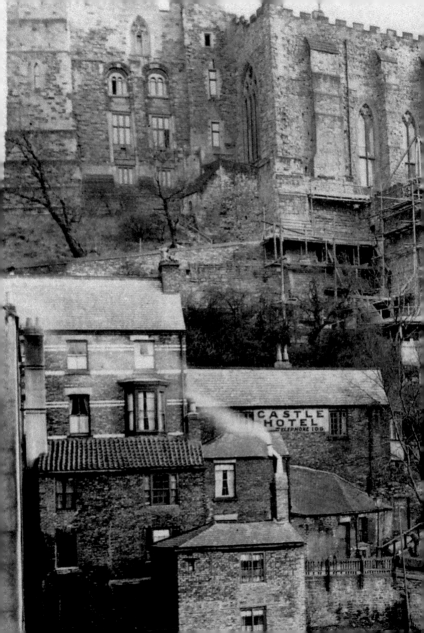

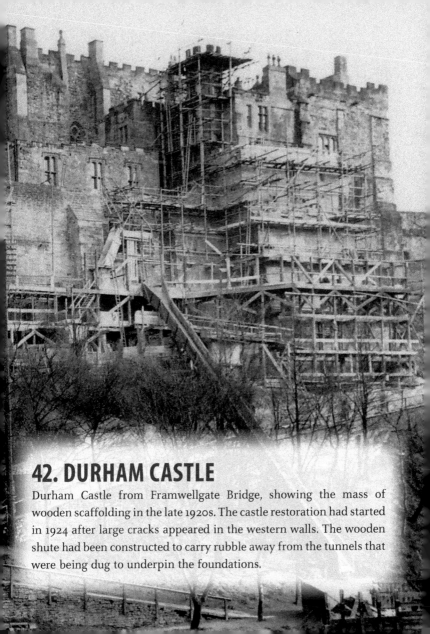

42. DURHAM CASTLE

Durham Castle from Framwellgate Bridge, showing the mass of wooden scaffolding in the late 1920s. The castle restoration had started in 1924 after large cracks appeared in the western walls. The wooden shute had been constructed to carry rubble away from the tunnels that were being dug to underpin the foundations.

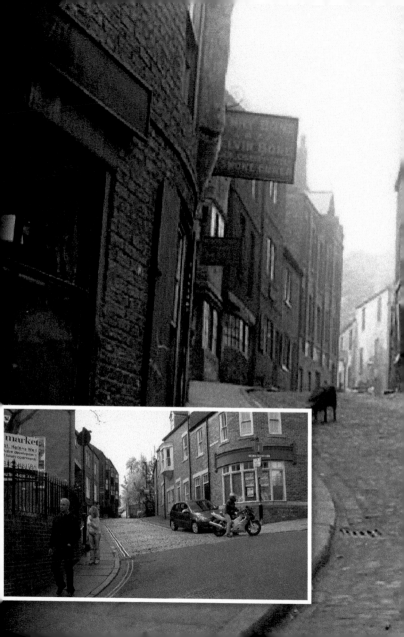

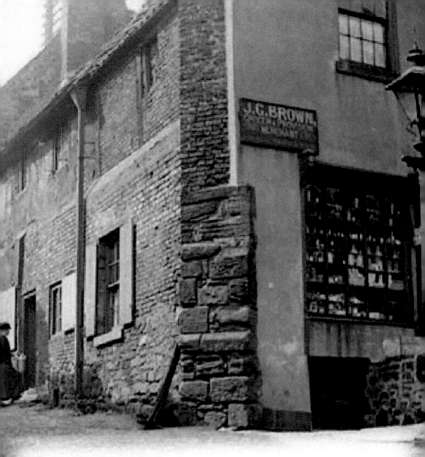

43. SOUTH STREET

The bottom of South Street from Crossgate, early 1900s. On the left is the sign of Henry Bone, chimney sweep, and, on the right, the provision shop of J. G. Brown. Some of these old buildings were timber-framed, a reminder is the gable-end of the nearby Fighting Cocks public house, which shows remains of the timber work of its former medieval neighbour.

44. MARGERY LANE

St Margaret's allotments viewed from Margery Lane, 1960s. In recent years they have had a new lease of life. The threat of them being sold by the Diocese, some years ago, heightened the importance of this area as a local amenity. They have now become very popular, due to the increasing cost of food and the need for outdoor exercise.

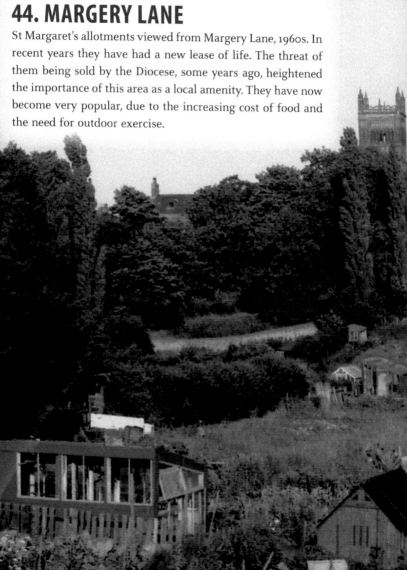

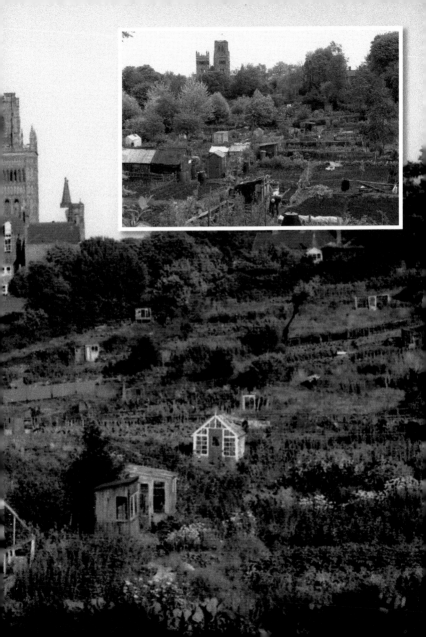

45. DURHAM CATHEDRAL

One of the oldest views of the cathedral overlooking Bellasis Farm and The Grove (with its walled garden reached by a tall gate in the south wall), *c.* 1855, taken by the Revd Henry Holden, headmaster of Durham School. This whole area, later became part of the present Durham School site.

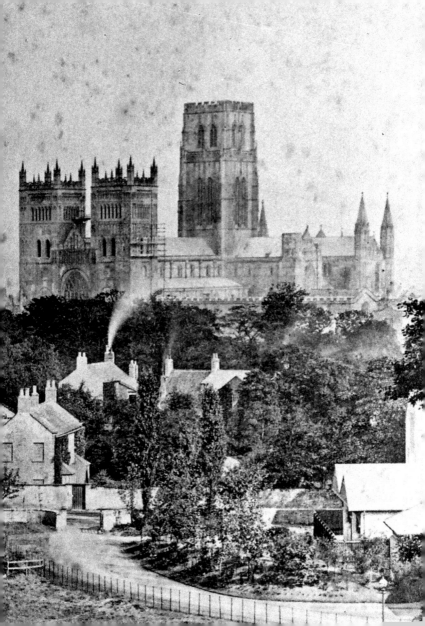

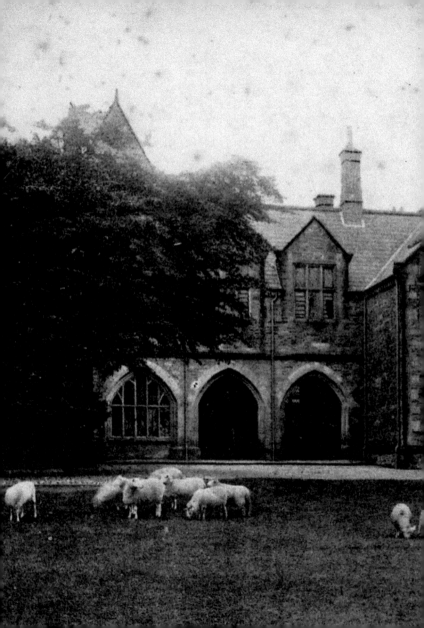

46. DURHAM SCHOOL

Sheep grazing on the playing field, Durham School, early 1900s. The school was founded around 1414 (the year before Agincourt) and was refounded by Henry VIII during the Reformation in 1541. The structure with the three arches was called the Arcade; on the right, with the large window, was the sixth-form room. These buildings were constructed when the school moved here in 1844.

47. THE AVENUE

The Avenue, Durham, 1900s. This is one of the few streets that hasn't altered very much, although many family homes have been let to students, thus altering the atmosphere of the street. The decorative railings above the bay window of No. 20, on the right, are no longer there. This road then linked up to Neville's Cross; it is now blocked at the top end with bollards.

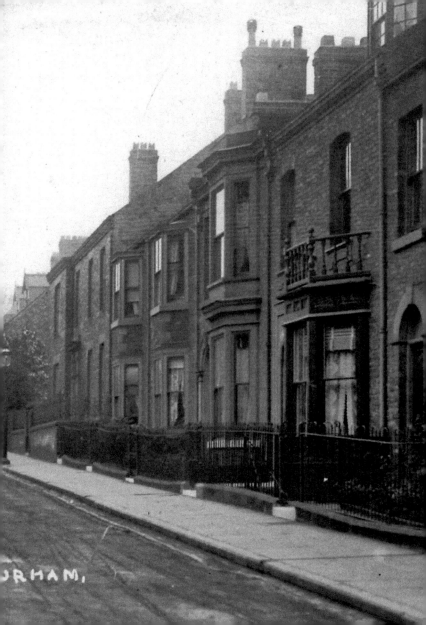

URHAM,

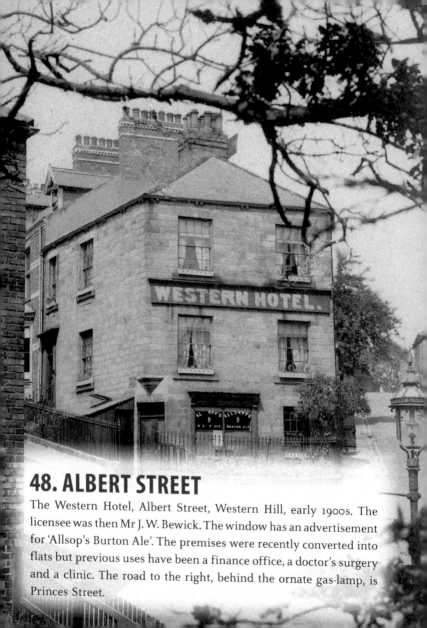

48. ALBERT STREET

The Western Hotel, Albert Street, Western Hill, early 1900s. The licensee was then Mr J. W. Bewick. The window has an advertisement for 'Allsop's Burton Ale'. The premises were recently converted into flats but previous uses have been a finance office, a doctor's surgery and a clinic. The road to the right, behind the ornate gas-lamp, is Princes Street.

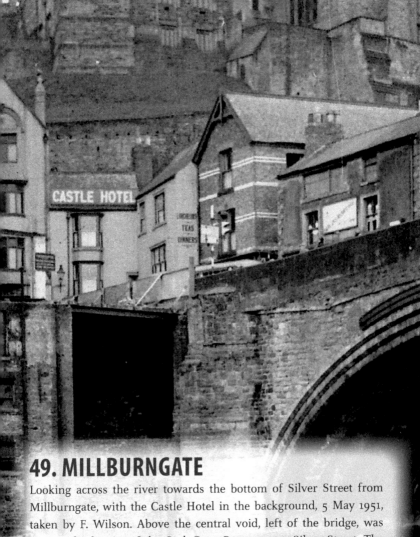

49. MILLBURNGATE

Looking across the river towards the bottom of Silver Street from Millburngate, with the Castle Hotel in the background, 5 May 1951, taken by F. Wilson. Above the central void, left of the bridge, was previously the site of the Cash Boot Company, 22 Silver Street. The open space underneath it (filled with rubble), exposed the original dry arch of Bishop Flambard's bridge (*c.* 1120).

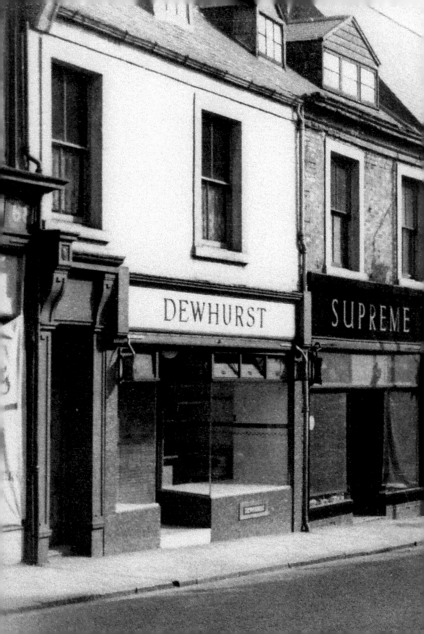

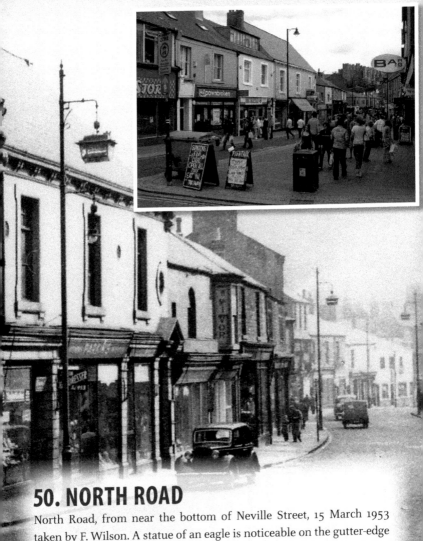

50. NORTH ROAD

North Road, from near the bottom of Neville Street, 15 March 1953 taken by F. Wilson. A statue of an eagle is noticeable on the gutter-edge of the roof belonging to the Supreme sweet shop, 70 North Road. The building on its right (upstairs) was the Shakespeare Hall; it was opened as a community centre in 1948 and is still in popular use today.

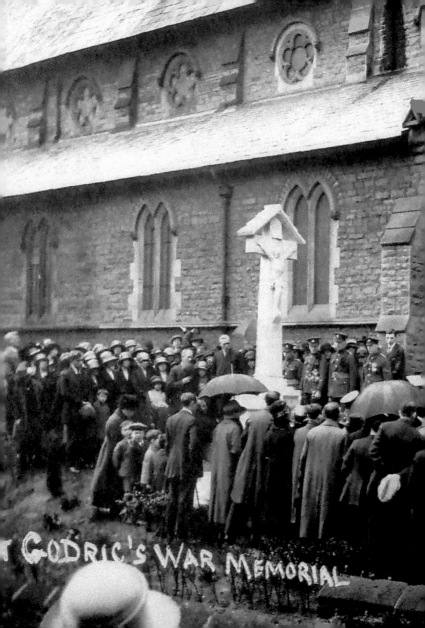

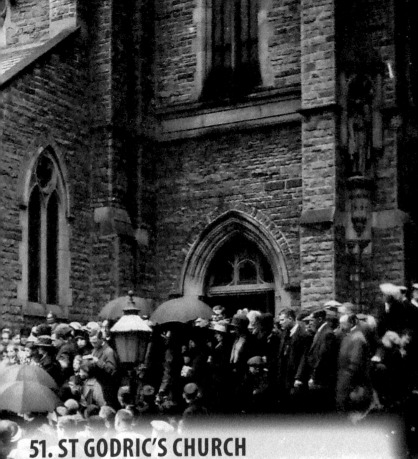

51. ST GODRIC'S CHURCH

The unveiling of St Godric's First World War memorial, 13 May 1923.
This calvary cross, in memory of forty men from the parish, was made
of Portland stone. It was unveiled by Lt-Col. J. R. Ritson and dedicated
by the Reverend Canon Thornton. The church was consecrated in 1864
and was designed by E. W. Pugin, son of the more famous A. W. N.
Pugin. The tower was added 1909/10. The church was badly damaged
in a fire of 14 January 1985.

52. DURHAM RAILWAY STATION

The old stationmaster's house, Durham railway station, 16 July 1965, taken by F. Wilson. This fine Victorian structure was demolished shortly after the photograph was taken; the south-bound entrance, now occupies this site. The road to the right leads under the main line, towards the north side of the station.

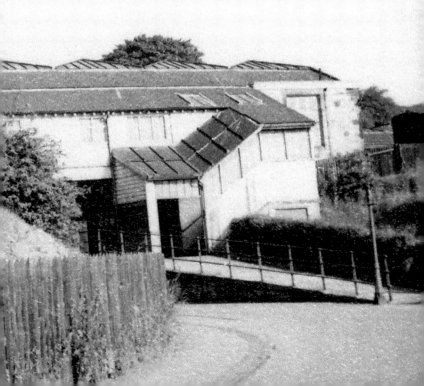

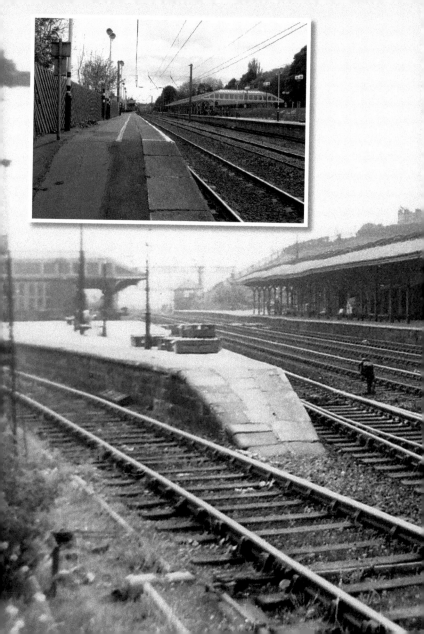

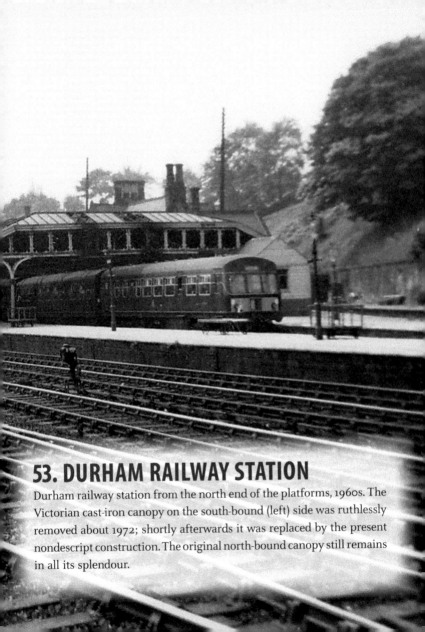

53. DURHAM RAILWAY STATION

Durham railway station from the north end of the platforms, 1960s. The Victorian cast-iron canopy on the south-bound (left) side was ruthlessly removed about 1972; shortly afterwards it was replaced by the present nondescript construction. The original north-bound canopy still remains in all its splendour.

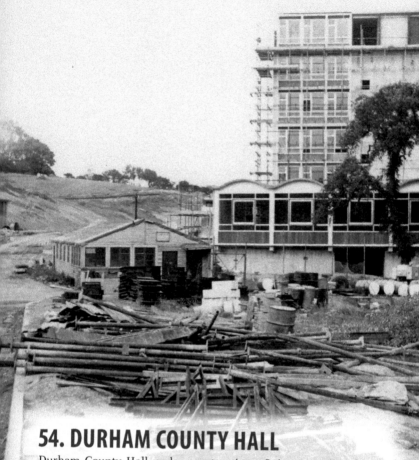

54. DURHAM COUNTY HALL

Durham County Hall under construction, 28 August 1962, taken by
F. Wilson. Prior to this the headquarters of the council was at Shire
Hall, Old Elvet. It was opened 14 October 1963 by the Duke of
Edinburgh. Designed by Clayton and Gelson (the county architects), it
was built by John Laing & Son Ltd, of London.